ROYAL
OPERA
HOUSE

CW00544799

SOUVENIR GUIDE

First published in 2012
by the Royal Opera House

Copyright © Royal Opera House 2012

ISBN: 978-1-84943-167-5

Acknowledgements:
Francesca Franchi, Paul Higgins, James
Hogan, Robert Perry, Barry Stewart

Commissioning Editor, Royal Opera House:
John Snelson

Cover and book design:
Dominik Klimowski

Photographs by:
Dominik Klimowski

Photograph and illustration credits:
ROH Collections 6, 11, 12, 14-15, 17
©ROH 2009/Catherine Ashmore 8
©Dee Conway 20-21, 22-23
©ROH 2010/Johan Persson 24-25
©Clive Barda 26-27
©ROH 2011/Johan Persson 30-31, 68-69
©ROH 2011/Mike Hoban 32-33, 45
©Will Pearson 39
©ROH 2011/Tristram Kenton 46-47
©ROH 2011/Bill Cooper 70

Prepared for the Royal Opera House
by Oberon Books Ltd.
Info@oberonbooks.com
www.oberonbooks.com

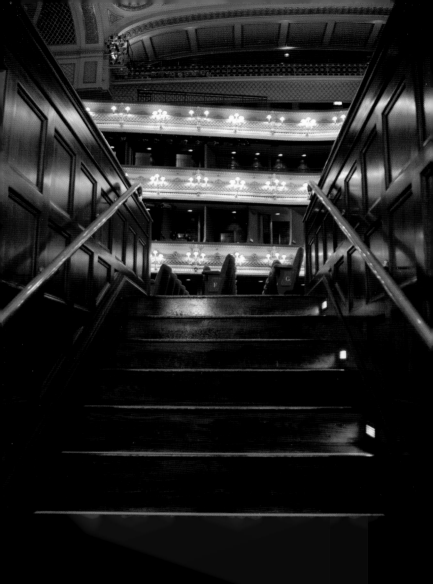

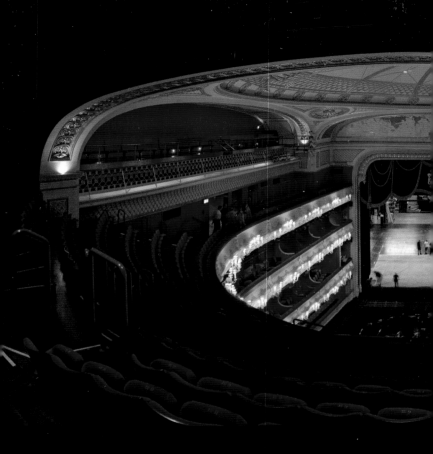

The auditorium and stage of the Royal Opera House as seen from the Amphitheatre. For generations it has played host to the world's greatest opera singers and ballet dancers – appearances by such legendary performers as Maria Callas, Joan Sutherland, Luciano Pavarotti, Margot Fonteyn and Rudolf Nureyev. The resident

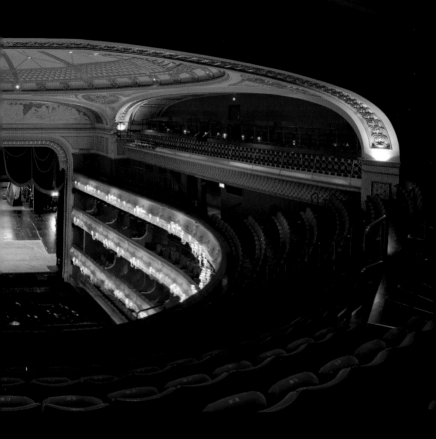

companies The Royal Opera and The Royal Ballet continue to give more than 300 performances each year, enjoyed by audiences in the grand theatre as well as broadcast to outdoor screens around the country, live in cinemas around the world, on television, on radio and online, and released on DVD and Blu-ray.

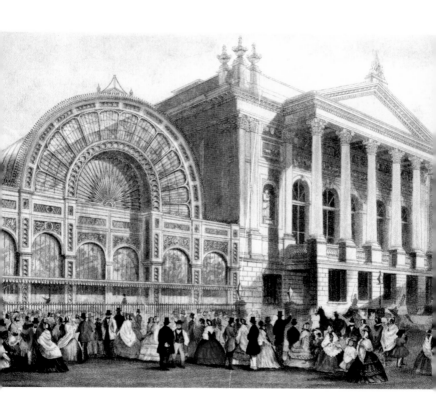

The Royal Italian Opera, Covent Garden, 1858
(now called the Royal Opera House)

The Royal Opera House in Covent Garden is the permanent home of The Royal Opera, The Royal Ballet, the Royal Opera Chorus and the Orchestra of the Royal Opera House. This fine building is a living centre for great operas, ballets and music, performed to world acclaim. The richness of the international repertory of established classics and exciting new works expresses the character and achievements of all those who have striven to place the Royal Opera House at the centre of the nation's cultural life.

The present theatre was built in 1858. It closed 1997–9 for radical rebuilding and is now one of the most architecturally impressive and technically advanced opera houses in the world. The majestic red, cream and gold auditorium and its immense proscenium arch framing the famous main stage, remain intact, while the much extended complex incorporates the Linbury Studio Theatre, the Clore Studio Upstairs and spacious public areas including restaurants, bars and a roof terrace. There are two full-size opera rehearsal stages, and extensive spaces for ballet rehearsals and classes.

This souvenir guide describes the Royal Opera House as a working theatre and one of London's landmark attractions. For up-to-date information about Royal Opera House activities, including performances, educational programmes, exhibitions and guided tours, visit **www.roh.org.uk**

Carmen, The Royal Opera (Director Francesca Zambello). Bizet's opera is one of the most popular of all operas and has been performed at Covent Garden more than 500 times.

THE ROYAL OPERA HOUSE STORY

The theatre has a rich and turbulent history central to the development of opera and ballet in Britain. The present building is the third on this site, refurbished at various times to meet changing demands. Its evolution over three centuries is inseparable from the commercial and artistic ambitions of successive impresarios and a host of pioneers of opera and ballet. The establishment of the Royal Opera and Royal Ballet companies at the Royal Opera House after World War II, and the support over the decades of the Arts Council, National Lottery Funding and generous private philanthropy, has secured the place of the Royal Opera House in world culture. The House's great performing companies, both resident and visiting, also owe their existence to the artistic achievements of great musicians, conductors, composers, choreographers and performers, whose work spans three centuries.

THE FIRST THEATRE

The story begins in 1732, when theatre manager John Rich built his Theatre Royal on the site of the present opera house (not to be confused with the other Theatre Royal in Drury Lane, which dates from 1663). The principal opera house at the time was the Italian Opera in the Haymarket, about a mile away.

Both the Drury Lane and the Covent Garden theatres had taken the name Theatre Royal, since both functioned by virtue of Letters Patent granted by King Charles II after his restoration to the throne in 1660. Charles issued Letters Patent to licence a limited number of theatres to prevent them being openly critical of the monarchy. But the arts have always found ways of getting their messages across, and theatres continued freely to present plays and satires critical of the Crown and government.

The Covent Garden theatre was financed by the enormous profits earned from Rich's production of John Gay's ballad opera *The Beggar's Opera*, a tale of pickpockets and thieves, characters drawn from London's underworld. Rich himself was a celebrated actor and Harlequin. Not surprisingly, his original intention was to build a playhouse in Covent Garden to stage plays and pantomimes enlivened by spectacular effects and stage tricks. But fashions change as always and theatres have to respond to new demands. Rich's diversions into other entertainments had already introduced serious opera and music to Covent Garden, and he set a new standard of musical composition at Covent Garden when he invited George Frideric Handel's company to give seasons of opera.

Handel was already in great demand as a prolific composer of operas in the Italian style. He was a celebrity in London, then Europe's largest city, and in his day the most influential figure on the London opera

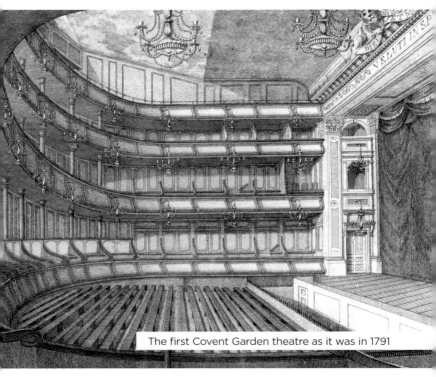

The first Covent Garden theatre as it was in 1791

scene. Covent Garden presented the premieres of numerous operas by Handel including *Ariodante*, *Alcina* and *Atalanta*. Performances of plays were prohibited during Lent (the six weeks leading up to Easter), so Rich presented seasons of oratorio for which Handel composed several new works, including *Samson*, *Judas Maccabeus* and *Solomon*. In 1743 the first performance in England of Handel's *Messiah* – still the most performed oratorio in Britain today – was at Covent Garden.

Dance had already entered Covent Garden programmes in a rather interesting guise. The French dancer and actress Marie Sallé was a great favourite at Covent Garden, appearing in dance sequences in Handel's operas and in her own ballets. She was a revolutionary who shocked her audiences by appearing barefoot in a Grecian-style muslin dress with free-flowing hair (as did Isadora Duncan some 200 years later).

THE SECOND THEATRE

The first major disaster struck in 1808, while the theatre was under the management of actor-manager John Philip Kemble. The theatre burnt to the ground (it is said that a gunshot set the scenery alight). The theatre was rapidly replaced by a new one to a design by Robert Smirke, later the

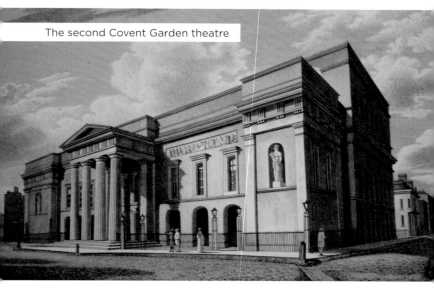

The second Covent Garden theatre

architect of the British Museum. It was vast and grandiose, the largest theatre in the world, modelled to some extent on the Parthenon in Athens, with an imposing facade on Bow Street. It opened in 1809 with a production of Shakespeare's *Macbeth*. For the next 50 years Covent Garden was devoted to a wide range of opera, ballet, music and drama including lavish productions of various plays by Shakespeare. The composer Carl Maria von Weber was the musical director for a time. He composed his opera *Oberon* for Covent Garden, where it was first performed in 1826.

By now, ballet was taking a stronger place in the repertory. Marie Taglioni, the greatest exponent of Romantic ballet, danced in the 1832 London premiere of *La Sylphide* (an earlier version of the ballet than the Bournonville version familiar to audiences today). Promenade concerts were also introduced to Covent Garden around this time.

The vast auditorium became increasingly less suited to the more intimate style of stage presentation then becoming the fashion. With this and the introduction of the Theatres Act of 1843 (which broke the monopoly of patent theatres and allowed many more theatres to open), Covent Garden fell on hard times, and was closed in 1846.

In 1847, refurbished, the theatre re-opened as the Royal Italian Opera House with a performance of Rossini's *Semiramide*. This was a significant point in the history of opera at Covent Garden. The newly installed opera company had defected from its former home in the Italian Opera House not far away in the Haymarket (now Her Majesty's Theatre), following disputes with the management. So, at the expense of its rival opera house, Covent Garden acquired a resident company under the musical direction of the Italian conductor Michael (born Michele)

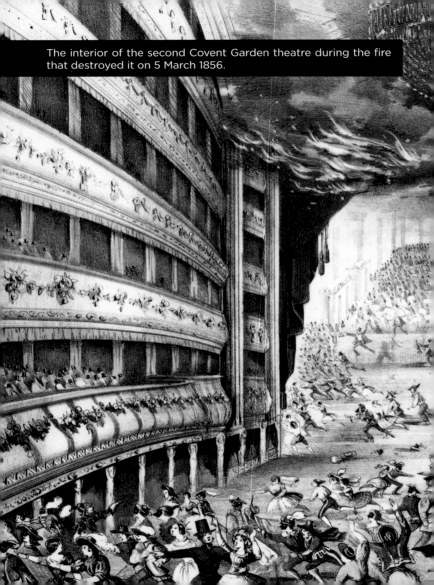

The interior of the second Covent Garden theatre during the fire that destroyed it on 5 March 1856.

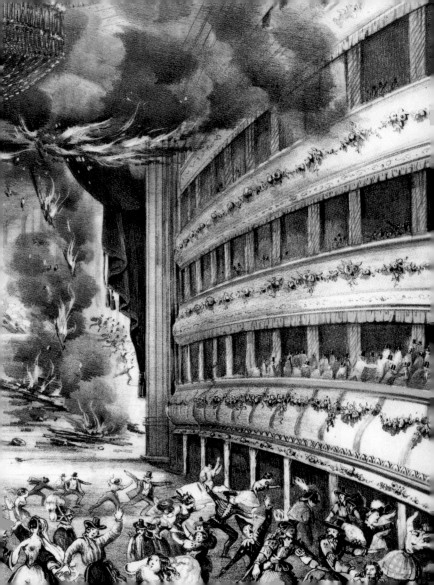

Costa. Queen Victoria and Prince Albert were keen supporters of the Royal Italian Opera, and attendance at the opera was an essential part of the social season.

In 1856, disaster struck again. Frederick Gye, the manager of the theatre, leased the building to a private promoter for a season of pantomime and entertainments, which culminated in a masked ball. The event got out of control and revellers, it seems, ran amok. The theatre caught fire and was completely destroyed.

THE THIRD THEATRE

Like a phoenix rising from the ashes, the Royal Italian Opera House was replaced by a majestic theatre of exquisite classical proportions, designed by E.M. Barry, the building we have today. It opened in May 1858 with a performance of Meyerbeer's *Les Huguenots*, and by the end of the 19th century, opera seasons were well established at Covent Garden.

In its new incarnation the Royal Italian Opera House (often simply called Covent Garden) attracted some of the greatest musicians and singers of all time including Adelina Patti, Nellie Melba and Enrico Caruso. What was once a theatre presenting sporadic programmes of opera, pantomime, drama and ballet was evolving into a major cultural institution and a national asset.

In 1892, with the repertory broadening to include French and German opera, the theatre was renamed the Royal Opera House. It was a remarkable year. Only 16 years after its premiere in Bayreuth in 1876, Wagner's *Der Ring des Nibelungen* was staged complete at Covent Garden in the summer of 1892, conducted by Gustav Mahler, no less. There were further performances of the first three operas in the cycle,

Das Rheingold, *Die Walküre* and *Siegfried*, in the following four years. The next complete *Ring* cycle was staged in 1898, conducted by Felix Mottl. The *Ring* has been staged at Covent Garden regularly ever since, in new and sometimes daring productions.

Winter and summer seasons of opera and ballet were presented at Covent Garden, and between seasons the theatre was either closed or used for film shows, dancing, cabaret and lectures. But it would be another 50 years before the Royal Opera House would be devoted entirely to opera and ballet as it is today.

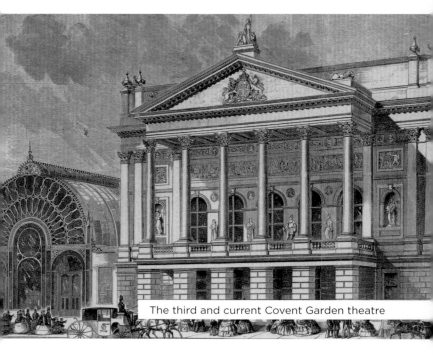

The third and current Covent Garden theatre

ENTERING THE MODERN AGE

In 1910, the conductor and opera impresario Thomas Beecham began his long association with the Royal Opera House. He focussed both on established works and on newly composed European operas. Notably, Beecham championed the music of Richard Strauss, introducing *Salome, Der Rosenkavalier* and *Elektra* to London audiences for the first time.

During World War I (1914–18) the theatre became a furniture repository and during World War II (1939–45) a Mecca dance hall. That's how it might have remained if the music publishers Boosey and Hawkes had not acquired the lease. In 1945 David Webster was appointed General Administrator, and the Sadler's Wells Ballet, under Ninette de Valois, was invited to become the resident ballet company.

The Royal Opera House re-opened on 20 February 1946 with a gala performance by the Sadler's Wells Ballet of *The Sleeping Beauty* with Margot Fonteyn as Aurora. This was a historic achievement for its founder Ninette de Valois. Margot Fonteyn (1919–91) is still honoured as the Prima Ballerina Assoluta of today's Royal Ballet.

With no suitable opera company able to take up residence, David Webster and Music Director Karl Rankl began to build a company from scratch. In December 1946 the embryo Covent Garden Opera teamed up with the Sadler's Wells Ballet in a production of Purcell's *The Fairy Queen* choreographed and directed by Frederick Ashton and conducted by Constant Lambert; the following January saw the Company's first performance of Bizet's *Carmen*. New works by English composers formed an ongoing part of the repertory. Benjamin Britten's operas *Billy Budd* and *Gloriana* were first performed at the Royal Opera House. So too was Michael Tippett's opera *The Midsummer Marriage*. The Royal Opera continues to commission and perform new operas, ever adding to its rich repertory.

Both companies were eventually awarded Royal Charters: The Royal Ballet in 1956, The Royal Opera in 1968. David Webster, who had played such a key part in establishing The Royal Opera and The Royal Ballet, ran the Opera House until his retirement in 1970.

THE THEATRE TODAY

By the 1980s, it was clear that the facilities at the Royal Opera House were inadequate for carrying its two great companies forward into the 21st century. Plans for a major redevelopment of the theatre were announced in 1984. The architects Jeremy Dixon and Ed Jones worked in collaboration with Bill Jack of Building Design Partnership (BDP), winning the competition to design the project. However, it was only after the creation of the National Lottery that the Royal Opera House was awarded £78.5 million towards the rebuilding costs and was able to begin work in 1996. Three years later at a total cost of £214 million, the theatre had been spectacularly transformed. Brand new technical and rehearsal facilities were built. A smaller auditorium – the 444-capacity Linbury Studio Theatre – was incorporated for smaller and experimental productions, while the existing auditorium and foyers were substantially refurbished. The architects of the redeveloped complex provided London with the world-class building so many had longed for.

The newly refurbished theatre opened on 1 December 1999 with a special gala performance in the presence of Her Majesty The Queen and broadcast live on BBC television. Extracts from opera and ballet were performed by The Royal Opera, The Royal Ballet, the Royal Opera Chorus and the Orchestra of the Royal Opera House.

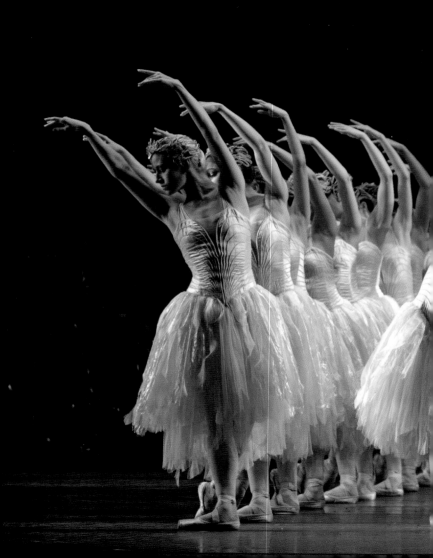

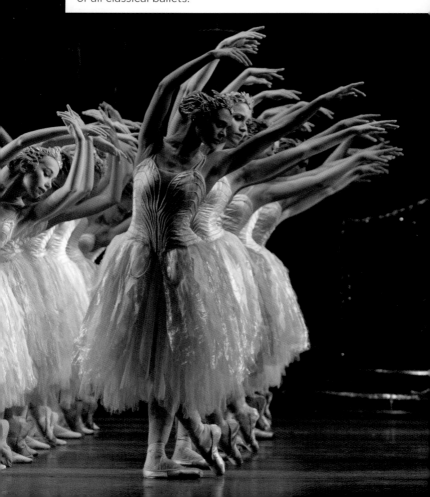

Swan Lake, The Royal Ballet (Production Anthony Dowell). *Swan Lake* is one of the best loved and most demanding of all classical ballets.

By far the greatest influence on ballet at Covent Garden, indeed in Britain, was Ninette de Valois, formerly a dancer in Sergey Diaghilev's company the Ballets Russes. She joined the company in 1923 and worked alongside the great choreographers, composers and designers in the company. The principal dancers at the time included Tamara Karsavina and Tamara Toumanova. Armed with first-hand experience of such extraordinary performers, De Valois returned to London to start her own ballet company, the Vic-Wells Ballet. This became the Sadler's Wells Ballet and eventually The Royal Ballet. De Valois was also the founder of The Royal Ballet School, whose Upper School now faces the Royal Opera House on Floral Street, along the north side of the theatre, and is joined by the distinctive twisting and award-winning Bridge of Aspiration.

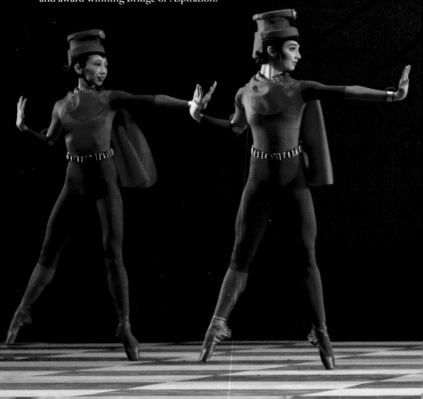

Inspired by Diaghilev, De Valois focussed on the collaboration between choreographer, composer and designer. Equally, she knew that the backbone of a company had to include the 19th-century classics, especially those created by Marius Petipa and Lev Ivanov, notably *The Sleeping Beauty* and *Swan Lake*. Her profound interest in new work paved the way for new choreographers – new explosive talents. A choreographer herself, she made many new works for her company, and as Diaghilev had done for the Ballets Russes, commissioned new music for them; Gavin Gordon (*The Rake's Progress*), Ralph Vaughan Williams (*Job*) and Arthur Bliss (*Checkmate*).

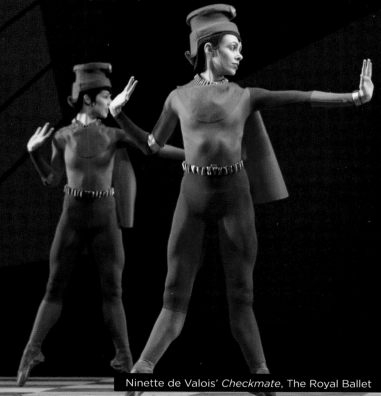

Ninette de Valois' *Checkmate*, The Royal Ballet

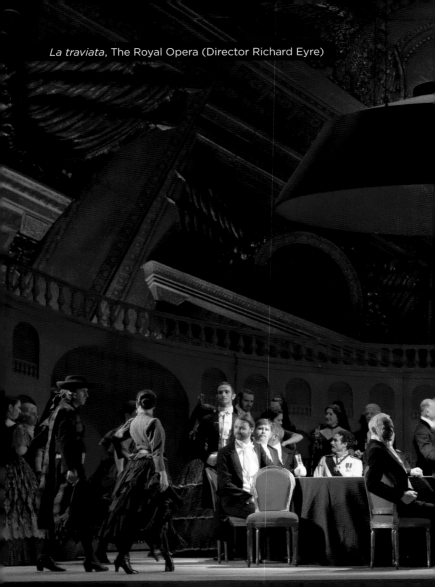

La traviata, The Royal Opera (Director Richard Eyre)

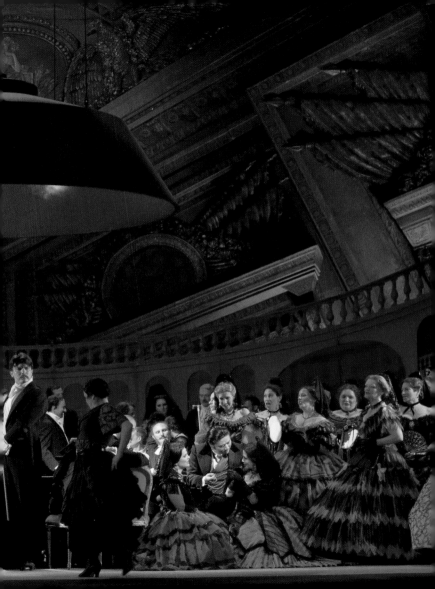

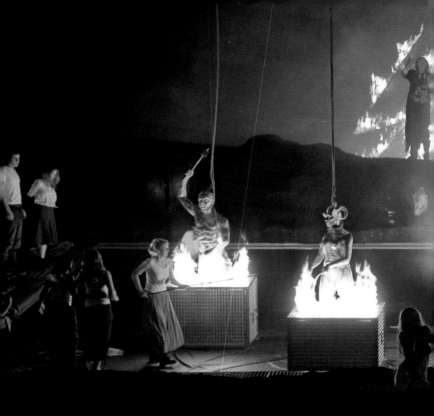

MUSIC DIRECTORS OF THE ROYAL OPERA

The Royal Opera was formed as the Covent Garden Opera Company in 1946. The first three Music Directors were Karl Rankl (1946–51), Rafael Kubelik (1955–58) and Georg Solti (1961–71). In 1968 the Company was renamed The Royal Opera and in 1971 Colin Davis was appointed Music Director. In 1987 Bernard Haitink succeeded Davis. Under his directorship the Company performed an imaginative range of repertory including award-winning new productions. Haitink also

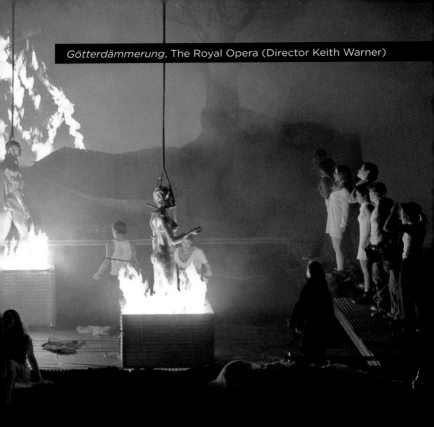

Götterdämmerung, The Royal Opera (Director Keith Warner)

fostered the Orchestra's concert appearances at Covent Garden and in major London concert halls. Antonio Pappano became Music Director in August 2002. Pappano has become well known for his extensive operatic repertory, which stretches from Mozart to Wagner, Verdi, Puccini and Richard Strauss, to key 20th-century works and world premieres including Birtwistle's *The Minotaur* and Turnage's *Anna Nicole*.

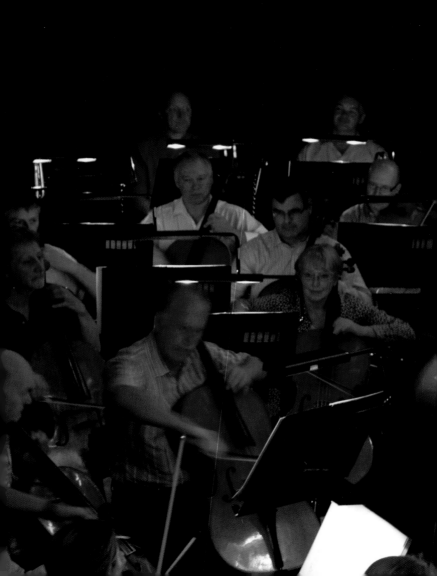

ORCHESTRA OF THE ROYAL OPERA HOUSE

The Orchestra of the Royal Opera House plays for The Royal Opera and The Royal Ballet. It also gives occasional concert performances, often with the Royal Opera Chorus for such large-scale choral works as Benjamin Britten's *War Requiem*. There is a regular group of some 106 players, supplemented for some of the biggest works, such as Wagner's *Ring* cycle. The orchestra plays music from almost four centuries, and has given the world premieres of music written for many new operas and ballets.

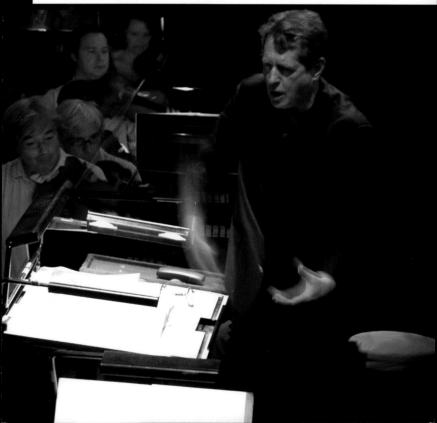

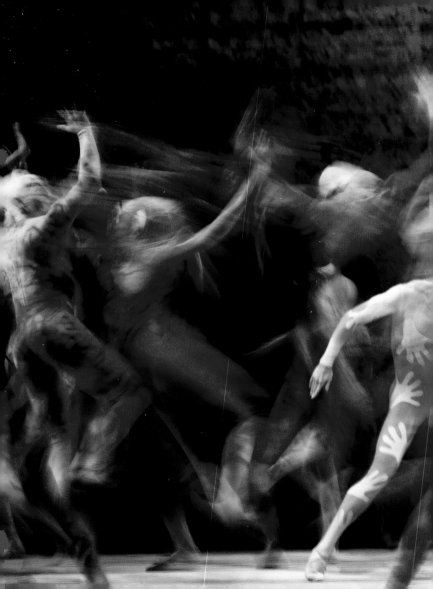

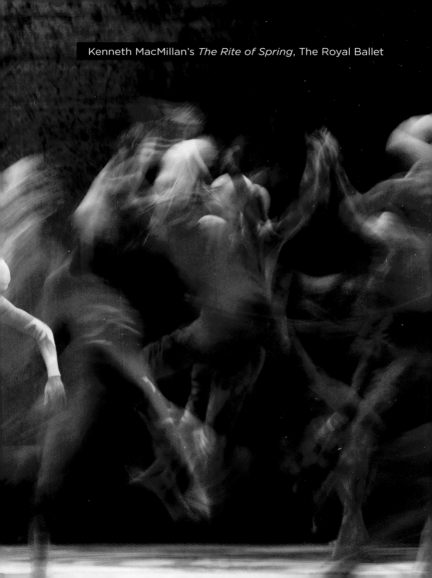

Kenneth MacMillan's *The Rite of Spring*, The Royal Ballet

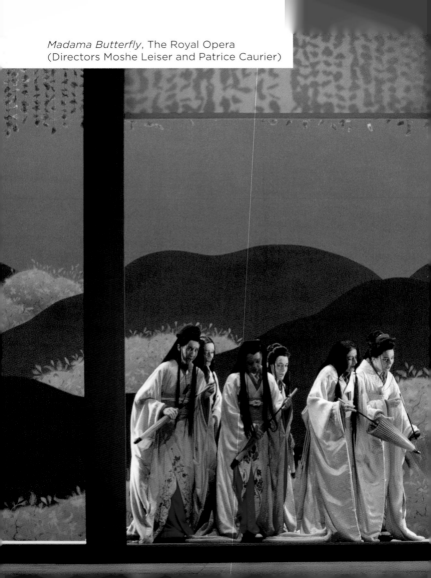

Madama Butterfly, The Royal Opera
(Directors Moshe Leiser and Patrice Caurier)

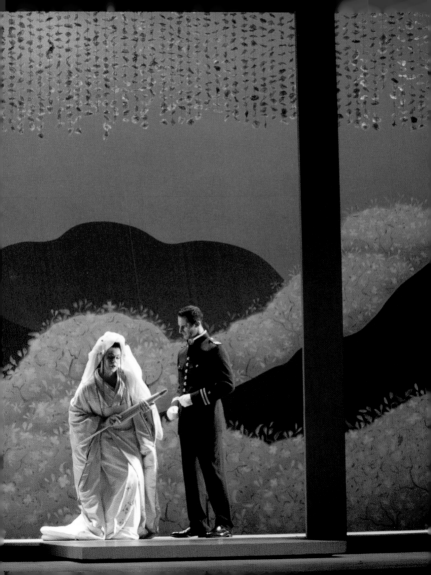

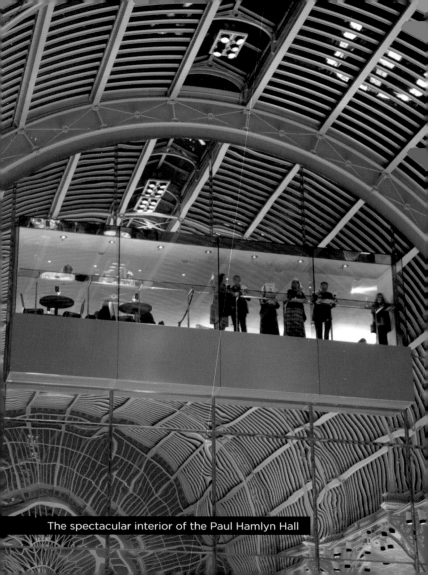

The spectacular interior of the Paul Hamlyn Hall

ARCHITECTURE

A stroll round the exterior of the Opera House reveals how the architectural challenges of incorporating the original 1858 Opera House, designed by E.M. Barry, into the much expanded new complex have been resolved. The whole building is integrated into the surrounding area, and much of it looks as if it might well have been part of the original theatre. Note how the south side of the Opera House blends into and completes the Inigo Jones-style colonnade along two sides of the Piazza.

At the Bow Street end the vast white Victorian facade remains unchanged with, beyond it, the 19th-century Foyer, Pit Lobby and Grand Staircase leading to the 'Crush Room'. But behind its soaring columns, which support the tympanum high above, a small conservatory was added in 1899, to extend the first-floor bar and foyer area. The friezes above the conservatory were salvaged from the fire that destroyed the previous theatre. They are inspired by the Elgin Marbles housed in the British Museum.

The ground-floor foyer was extended in the 1950s. Before then, this part of the building beneath the columns was an open carriageway for those who could afford carriages. In those days, patrons sitting in the upper parts of the theatre had to enter by a side entrance and climb a challenging stone staircase to reach their seats. How times change.

PAUL HAMLYN HALL (FLORAL HALL)

To the left of the theatre's facade is the exquisite glass and iron facade of the Paul Hamlyn Hall, designed by E.M. Barry and built shortly after the Opera House. Formerly known as the Floral Hall it was for a time the

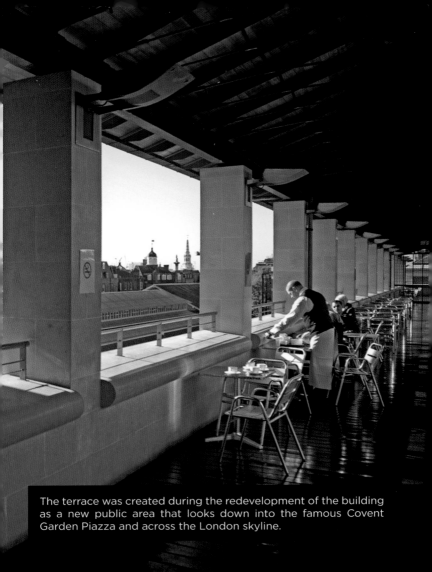

The terrace was created during the redevelopment of the building as a new public area that looks down into the famous Covent Garden Piazza and across the London skyline.

centre of the Covent Garden fruit, vegetable and flower market. In 2007 it was renamed the Paul Hamlyn Hall in recognition of the generous financial support given by the Paul Hamlyn Foundation.

Originally intended to form part of a much larger projected iron and glass arcade, which was never fully realized, the Floral Hall was built to provide additional income for the Opera House from the sale of exotic fruit and flowers. This enterprise was opposed and for some thirty years the building was used intermittently as a ballroom and concert hall. However, in 1887 it finally became part of the Covent Garden fruit, vegetable and flower market, until a fire destroyed the roof in 1956. The virtually derelict building was acquired by the Royal Opera House in 1977 and used to store scenery. Now incorporated into the redeveloped complex, it spectacularly provides the main public promenade area, with bar and restaurant facilities. Ingeniously, the whole structure was raised to make space beneath for the new box office, larger cloakroom facilities and the entrance to the subterranean Linbury Studio Theatre.

Both the exterior and interior of the Paul Hamlyn Hall are visually exciting. As in much impressive architecture, it is pleasing to the eye to see plainly the structural components that support this fine building. One could say the same of so many great buildings – from the two-tier colonnade of Doric columns of the Parthenon in Athens to the elegant flying buttresses of medieval Gothic cathedrals. The classical model was not lost on E.M. Barry when he designed the Opera House and gave it its magnificent neo-classical facade with six massive Corinthian columns.

Inside, today's architects have added additional features: one of the tallest escalators in a public building in the UK – to reach the Amphitheatre Bar and Restaurant – and a viewing gallery to look down

upon the Paul Hamlyn Hall. At the top of the escalator is the spacious Amphitheatre Bar, with a restaurant on the left for lunch and pre-theatre dining. Ahead is the exit to the roof terrace with a view of the skyline along the River Thames, affording glimpses of famous landmarks including Nelson's Column and the London Eye. Down below is the bustling Covent Garden Piazza, thronging with cafés, bars, street performers, shops and, at times, street fairs. A walk along the terrace also offers a view through the windows of the Costume Workroom.

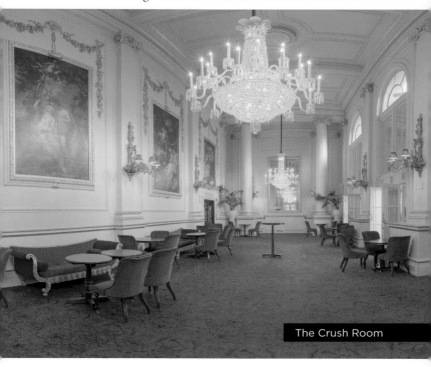

The Crush Room

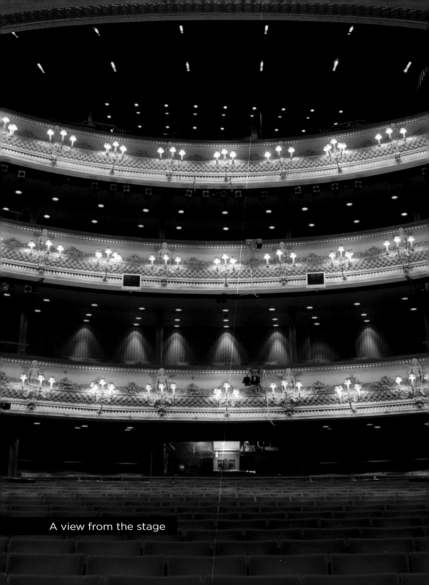

A view from the stage

THE AUDITORIUM

London has many fine Victorian theatres. The Royal Opera House is the largest, seating some 2,255 people. This majestic auditorium has recently been restored to its full splendour. It speaks eloquently of a golden age of opera, ballet and music performed in this theatre since 1858. Almost all the legendary singers one could name have appeared at Covent Garden through the ages and have been cheered in this auditorium. Likewise, the greatest dancers of our time have either joined The Royal Ballet or appeared as guest artists, or performed here with their own companies such as the Mariinsky (Kirov) Ballet, Bolshoi Ballet, American Ballet Theatre, New York City Ballet and many more.

Barry's auditorium was built to the general pattern of most 19th-century Italianate opera houses. Surrounding the spacious Orchestra Stalls there are four horseshoe shaped tiers: the Stalls Circle, the Donald Gordon Grand Tier, the Balcony and the Amphitheatre. But Barry's original design has been altered in one important respect: many of the boxes have been removed, and the divisions between the relatively few remaining boxes are discreet. As a result, the visually dominant, uninterrupted lines of the four tiers draw the eye to the proscenium arch and, once the curtain rises, directly to the stage itself. The overall effect is awesome and intimate at the same time.

The proscenium itself is 12.3m (40ft) high and 14.8m (49ft) wide, flanked by attractive gilded barleycorn twists. The inner twists can be adjusted to narrow the proscenium by up to 2m (6ft). All the gilding has been redone. Gold leaf (24 carat) was applied in thin sheets to highlight the plaster decorations. Nearer the stage, the gilding has been toned down to reduce reflection from the stage lighting. The tympanum

above spans the entire width of the proscenium. Theatre manager Frederick Gye offended his architect E.M. Barry, who had worked tirelessly on the building, by inviting Raffaele Monti to complete the plasterwork decorations in the auditorium. Monti modelled the life-size figures in the frieze in the tympanum above the proscenium to depict Orpheus on the left playing his lyre and Ossian on the right declaiming verse: representing the civilizing effect of music and poetry. In the centre is a medallion showing the young Queen Victoria supported by winged figures. By that time Victoria was some twenty years into her long reign (1837–1901).

Another attractive characteristic of the auditorium is the relatively understated Rococo style ornamentation, often overdone in theatres of its time. Even the coat of arms above the Royal Box is unobtrusive. Behind the lampshades along the tiers there are female figures referred to as 'The Ages of Women': aged seven on the Amphitheatre, 14 on the Balcony and 21 on the Donald Gordon Grand Tier. The flowers between them are moulded as buds higher up the auditorium to fully open at the lower level, reflecting the blossoming of the women to maturity. The predominant colours in the auditorium – red, gold and cream – are based on the original 1858 colour scheme, and not so different from many other 19th-century opera houses. Yet the many attractive electrified candelabras with red shades, spaced evenly along three of the four tiers, create a warm glow and enhance the intimate atmosphere. As the house lights go down, one can see panels in the dome slide away silently to reveal stage lighting high in the roof. The house curtains provide a massive block of colour, crimson with gold trimmings, decorated with the initials of the reigning monarch; they weigh almost three tons.

One of the most striking features of the décor is the pale blue saucer-shaped dome in the ceiling. The use of the colour blue is a tradition in

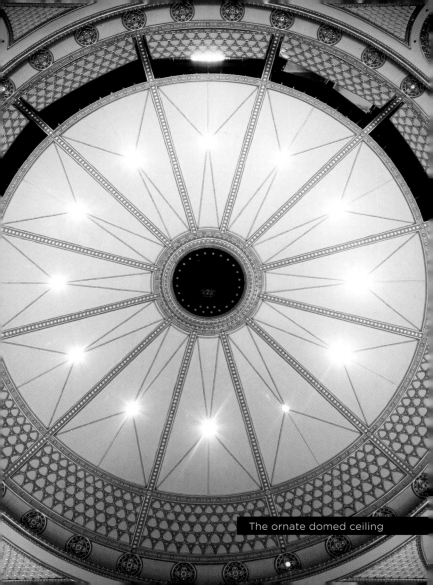

The ornate domed ceiling

theatre and reflects the open-air amphitheatres of Classical Greece. In the past, a huge gas-lit chandelier hung from the centre of the dome and remained lit during performances, along with gas-lit candelabras along the tiers. Imagine the intrepid gasman lighting all these gas jets with a long taper by leaning out of the central ventilation hole! The removal of the chandelier certainly improved the view from the Amphitheatre.

Once the curtain rises the stage seems vast. The performing area is 245.8m^2 (2646ft^2), which has given it slightly more depth than before the redevelopment. Even before this enhancement the stage was hardly small. Covent Garden audience veterans will remember Franco Zeffirelli's production of *Cavalleria rusticana* and what seemed like an entire Sicilian street reaching into the distance – part illusion perhaps, but also part stage depth. The new stage with all its state-of-the-art equipment now provides almost unlimited scope for set design and construction.

In the 19th century, however, the stage projected further out into the auditorium. The tympanum above the proscenium served as a sounding board for the singers. Acoustically speaking, the horseshoe-shaped auditorium allows sound to travel round the theatre, and the recent installation of the wooden floor also improves the acoustics. The floor under the seats accommodates the grilles for the air cooling system (silent of course).

The orchestra pit can accommodate up to ninety players. The entire level of the pit is changeable. It can be lowered to its deepest level for large orchestras, for example in large-scale works by Richard Strauss and Wagner; raised to a shallower level for chamber-sized orchestras as in Mozart operas; or raised to the same level as the stage for concert performances.

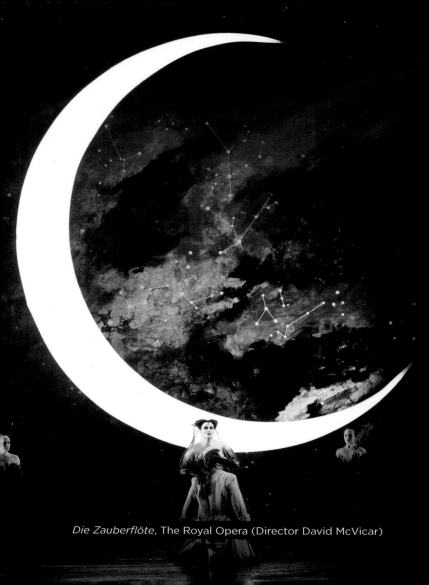

Die Zauberflöte, The Royal Opera (Director David McVicar)

LINBURY STUDIO THEATRE

The 444-capacity Linbury Studio Theatre below ground was a major addition to the recent Royal Opera House redevelopment. Designed as a fully flexible contemporary theatre with retractable seating, it serves as a second auditorium for small-scale opera and dance productions by ROH2 (the Royal Opera House's contemporary programming arm) and visiting independent companies. Although established small-scale works from all periods are performed, there is a strong emphasis on new work, including experimental productions, talks and interviews, educational and community projects, concerts and recitals. The Linbury Studio Theatre is one of the most technologically advanced new theatres in the country, and has been described as one of the best 'fringe' theatres in London. It has its own foyer and bar. The name Linbury is aptly derived from the Sainsbury family philanthropic organization, The Linbury Trust, and Anya Linden (Lady Sainsbury), a former principal dancer with The Royal Ballet.

CLORE STUDIO UPSTAIRS

The Clore Studio Upstairs is primarily used by The Royal Ballet for rehearsals and ballet class. It is named after Sir Charles Clore, the father of Vivien Duffield, a driving force behind the enormous fundraising effort for the redevelopment of the Royal Opera House. Ballet dancers must attend class regularly to maintain their technique. Class is taken by a ballet master/mistress and attended by principal dancers, soloists and corps de ballet members alike. The music is invariably played live by a rehearsal pianist.

Much time and cost have been saved since the Clore Studio and several other rehearsal spaces, large and small, were included in the

new development. Previously, classes were taken in rehearsal rooms in buildings elsewhere. Remember, given the many performances every Season, several ballets are often in rehearsal at the same time. The different ballet rehearsal studios in the building today have been named after great figures in The Royal Ballet's history: Dame Ninette de Valois (Founder Director), Sir Frederick Ashton (Founder Choreographer), Dame Margot Fonteyn (Prima Ballerina Assoluta), Constant Lambert (Founder Music Director), Sir Robert Helpmann and Sir Kenneth MacMillan.

The floor space of the Clore Studio closely matches the dimensions of the performing area on the main stage. Like all ballet studios, it features barres and mirrors, but with the additional benefits of natural overhead light, air conditioning and a sprung floor. A sprung floor is most important to soften jumps and protect the dancers' joints and muscles. Beneath the smooth surface rubber pads give 'bounce' to the floor, and felt padding dampens the sound of jumps and footwork. These features are also integrated into the ballet floor of the main stage (different from the floor used for opera), and The Royal Ballet even takes its own sprung floor on tour.

A guided tour of the Opera House may include a view of the Ashton Studio through soundproofed windows while a class or rehearsal is in progress. If you are lucky enough to catch a class, you may see several stars of The Royal Ballet practising at the same time. The Clore Studio Upstairs is also used as an additional performance space with a seating capacity of 170. A variety of outside companies are invited to use the space free of charge. This arrangement opens the theatre's facilities to the dance community, and helps with production and arts administration training, with the support of the Royal Opera House.

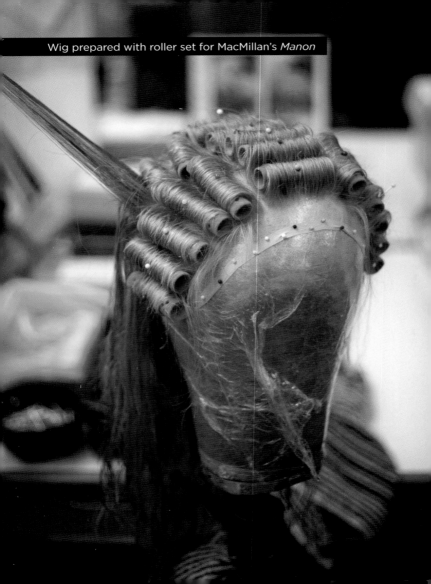

Wig prepared with roller set for MacMillan's *Manon*

Costumes for *Manon*

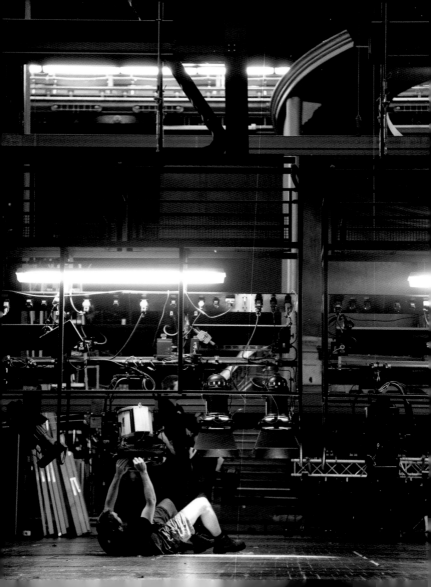

BACKSTAGE

Much of what the Royal Opera House requires backstage is within the building; costume making and fitting, and prop making included. However, before the 1997–9 redevelopment, the stage technology had not been fundamentally upgraded since Victorian times. There simply wasn't enough space. Computerization and advanced lighting systems alone were no longer sufficient to meet the increasing production and rehearsal demands of two resident companies. Improvements were long overdue.

The Opera House presents some 300 performances a year. Around forty different productions are presented on the main stage alone – more if visiting companies such as the Mariinsky or Bolshoi bring their own productions with them. The smaller Linbury Studio Theatre auditorium also presents events throughout the year including smaller scale opera and dance productions.

There are several booking periods in each Season. In any one period four or five operas may be in repertory as well as two or three full-length ballets or mixed programmes of two or three shorter ballets. Few opera houses in the world could present Kenneth MacMillan's full-length ballet *Romeo and Juliet* at 12.30pm, followed by Verdi's *Macbeth* at 7.30pm. A performance schedule of this order calls for remarkable stage management responsibilities. Everything must be in the right place at the right time. The practical side of dealing with such a heavy demand on technical resources requires rapid flexibility, technical sophistication and a high degree of professional skill, craftsmanship, administration, marketing and publicity.

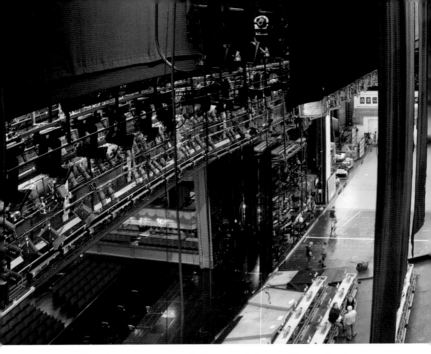

Before the expansion of the Royal Opera House backstage area, rehearsals took place at different locations in London. It made commercial sense to bring everyone into the same building complex, rather than waste time and money moving dancers, singers and musicians around London.

A typical weekly schedule for The Royal Opera might include rehearsals for up to five operas. Opera rehearsals take place in two huge rehearsal rooms on the two full-size mobile rehearsal stages, complete with scenery. The rehearsal stages slot into the main stage without the need to dismantle the scenery. This technological advance enables the

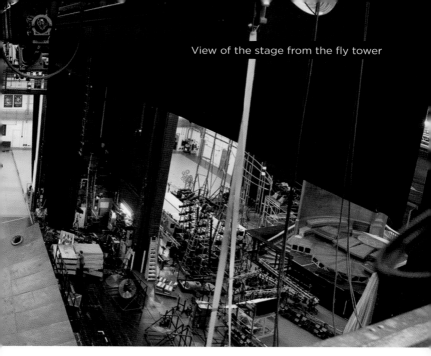

cast of an opera to become familiar with the layout of the set much
earlier in the rehearsal room.

The Royal Ballet rehearses on stage and in specially designed rehearsal
studios, three of which match the dimensions of the main stage.

THE WAGON SYSTEM

The main stage and large backstage spaces are operated by a wagon
system, a recent innovation in stage technology. Essentially, the wagon
system is a moving floor, divided into sections. The wagons are moved
by a mechanical traction system. Each section can be moved by remote

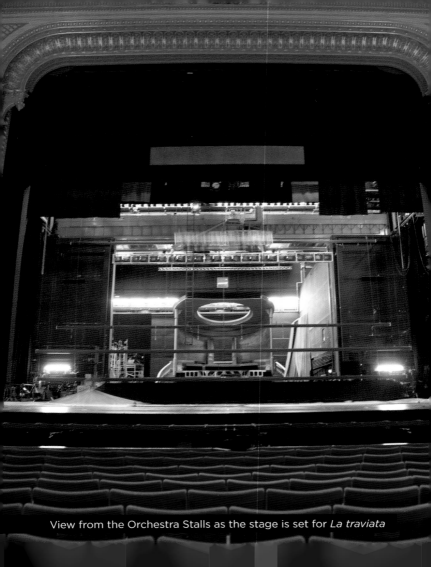

View from the Orchestra Stalls as the stage is set for *La traviata*

controls across or between other sections to carry scenery on to the main stage. It takes only 40 seconds for an entire set to move from side stage onto the performing area. Picture a chessboard in which each square can be moved from one side of the board to the other by lowering certain sections to enable other squares to pass over them.

Currently there are 21 wagons for opera and a further six for ballet (with sprung floors). Technical experts are on hand to change scenery during performances and in intervals. The whole system is capable of carrying up to thirty tons of scenery to the stage.

THE FLY TOWER

The fly tower is the tallest part of the building, rising directly above the stage. As in many theatres it is visible from outside the building. All theatre goers are aware that scenery and front stage curtains and safety curtains rise up into the fly tower. The main advantages at the Opera House are the dimensions and architectural elegance. The fly tower now rises to a height of 37m (121ft) and is designed in classical style to blend in with the rest of the building. The best view is from the south side of Covent Garden Piazza.

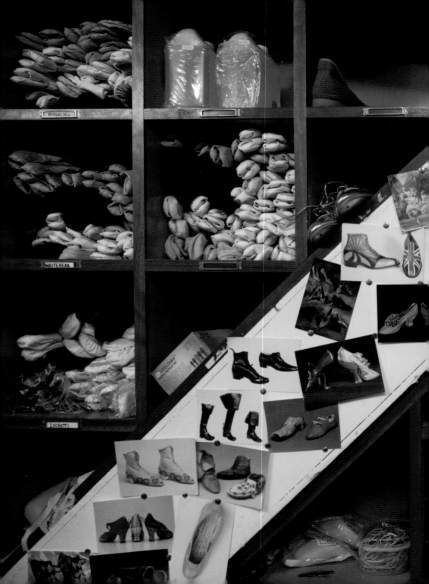

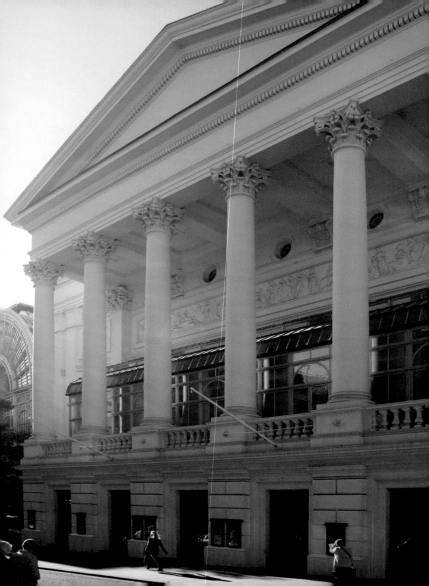

HOW TO GET HERE

The Royal Opera House and the surrounding area of Covent Garden is a popular destination for visitors. An imposing white building, the Opera House towers above the busy Covent Garden Piazza in the heart of London's West End, a cosmopolitan area bustling with street performers, cafés, shops and bars.

The Royal Opera House is also well served by public transport. The nearest underground station is Covent Garden on the Piccadilly line. Turn right out of the station and head for the Piazza (two minutes walk). At the Piazza, turn left along the colonnade of shops to the rear entrance of the Opera House. Alternatively enter by the front entrance in Bow Street, all within walking distance of Trafalgar Square, Leicester Square and the Strand.

WHAT'S ON

Brochures containing full details of present and future performances are available in the foyers, which link Covent Garden Piazza to Bow Street. To book online visit **www.roh.org.uk**

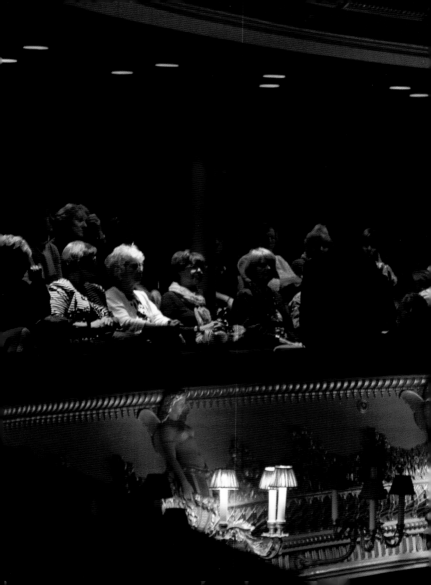

BACKSTAGE TOURS

Backstage Tours offer an exciting overview of this stunning building, including the backstage area, the historic Front of House, and the elegant Paul Hamlyn Hall. You'll gain an insight into the colourful history of the theatre, learn about the state-of-the-art technology and perhaps take a look at aspects of current opera and ballet productions.

Each tour is unique, varying according to what is available on the day. While access to the auditorium cannot be guaranteed, tours may include opportunities to see The Royal Ballet in class, a production workshop and the magnificent backstage technology at work.

Tours usually begin at 10.30am, 12.30pm and 2.30pm, Monday to Friday, and 10.30am, 11.30am, 12.30pm and 1.30pm on Saturday, except when there is a performance in the main auditorium. Each tour takes about 75 minutes. Special 'Velvet, Gilt and Glamour' tours focus on the glorious auditorium only: these take place most days at 4pm and last 45 minutes.

Please check ticket availability with the Box Office. You can book in person at the Box Office, online at **www.roh.org.uk/tours** or by telephone on **+44 (0)20 7304 4000**. The tour route is fully accessible to wheelchair users, but is not suitable for children under eight.

WINING AND DINING

Royal Opera House Restaurants provides catering and hospitality throughout the Royal Opera House. Royal Opera House Restaurants includes the Paul Hamlyn Hall Balconies Restaurant and Champagne Bar, the Amphitheatre Restaurant and Bar as well as the Crush Room, Conservatory and private dining rooms. All restaurants and bars offer the option of dinner before and during the intervals of performances. Our menus are seasonal and British and have a wide range of dining options to suit you. The Amphitheatre Restaurant menu is à la carte and in the summer it is possible to eat al fresco on the terrace with spectacular views over Covent Garden. We ask you to pre-order in our other restaurants and bars to ensure you have a relaxed and enjoyable evening. The Amphitheatre Bar and the Paul Hamlyn Hall Bar offer a selection of sandwiches and salads while patrons can enjoy a wide range of cold food in the sumptuous surroundings of the Crush Room, including open sandwiches and fresh lobster. You can pre-order drinks (including Ruinart champagne) and meals online when you book tickets for performances. The Amphitheatre Restaurant and Bar are also open for lunches Monday – Saturday.

You can make your reservations by telephone on **+44 (0)20 7212 9254** or alternatively e-mail **restaurants@roh.org.uk**

THE ROYAL OPERA HOUSE SHOP

You are sure to find the perfect memento of your visit to our inspirational opera house in our gift shop.

London's leading specialist store for all things related to ballet and opera, the shop offers an exceptional range of video and audio recordings alongside a wide selection of giftware, stationery and clothing.

Open Monday to Saturday from 10am to 7.30pm (with special trading hours on Sundays if there is a main house performance), the shop is situated next to the Box Office, just off Covent Garden Piazza, and there is also a pop-up shop selling merchandise in the Paul Hamlyn Hall at performance times.

You can also shop for our merchandise online at **www.roh.org.uk/shop**, or telephone us on **+44 (0)20 7212 9331** – we'll ship to you anywhere in the world.

OPUS ARTE

Opus Arte is the Royal Opera House's multi-platform arts production and distribution company. One of the world's leading providers of high-quality classical music content, releasing around twenty titles on DVD, Blu-ray and CD each year, Opus Arte also produces and directs programmes that are broadcast in over sixty countries and licenses content to some of the world's leading businesses.

For full details of the Opus Arte catalogue, please visit **www.opusarte.com**

ROYAL OPERA HOUSE
LIVE CINEMA SEASON

The Royal Opera House screens many of its performances live in cinemas across the UK and around the world in High Definition and 5.1 Surround Sound. To find out how you can enjoy some of the world's best loved opera and ballet as though you are sitting in the best seats in the House, please visit **www.roh.org.uk/cinema**

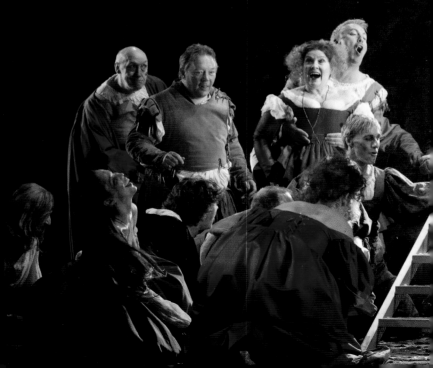

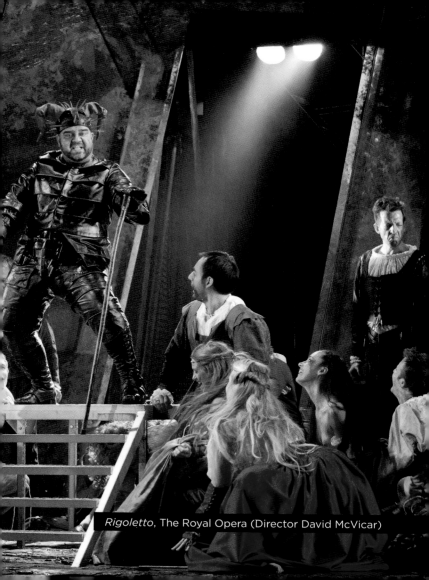

Rigoletto, The Royal Opera (Director David McVicar)

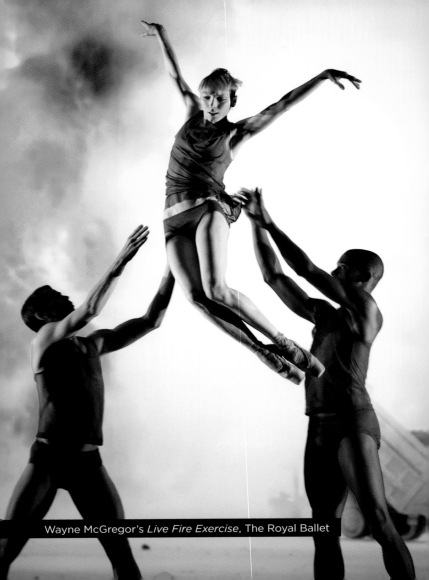

Wayne McGregor's *Live Fire Exercise*, The Royal Ballet

TIMELINE

1732	John Rich completes his Theatre Royal, Covent Garden, the first theatre on the Covent Garden site.
1735	Premiere of George Frideric Handel's opera *Ariodante*.
1743	First performance of Handel's *Messiah* in England.
1803	The actor John Philip Kemble becomes manager of the Theatre Royal.
1808	Fire destroys the Theatre Royal.
1809	Second theatre on the site opens with a performance of Shakespeare's *Macbeth*.
1820	Charles Kemble becomes owner and manager.
1826	Premiere of Carl Maria von Weber's opera *Oberon*.
1839	Madame Vestris and Charles James Mathews take over the management.
1846	Theatre closes due to financial problems.
1847	The Theatre re-opens as the Royal Italian Opera House.
1856	Fire destroys the Opera House.
1858	The third and present theatre is completed and opens with a production of Meyerbeer's opera *Les Huguenots*.
1892	The theatre is renamed the Royal Opera House.
1892	First production of Wagner's complete *Ring* cycle in the UK, conducted by Gustav Mahler.
1911	Diaghilev's first Ballets Russes season at the Royal Opera House.
1913	Thomas Beecham produces and conducts the first UK performances of Richard Strauss's *Der Rosenkavalier*.
1931	The Vic-Wells Ballet, precursor to The Royal Ballet, is formed by Ninette de Valois and Lilian Baylis in London.
1933	Thomas Beecham becomes Artistic Director and Principal Conductor at the Royal Opera House.
1939	Theatre converted into a Mecca dance hall during World War II.
1945	David Webster appointed General Administrator.
1945	The Sadler's Wells Ballet under Ninette de Valois becomes the resident ballet company at the Royal Opera House.
1946	Sadler's Wells Ballet re-opens the Royal Opera House with a new production of *The Sleeping Beauty* with Margot Fonteyn as Aurora.
1947	Bizet's *Carmen* is performed, the first complete opera production at the Royal Opera House since the end of World War II.
1948	Premiere of Frederick Ashton's ballet *Cinderella*, his first full-length work.
1951	Premiere of Benjamin Britten's opera *Billy Budd*.
1952	Maria Callas debut at Covent Garden in *Norma*.
1953	Premiere of Britten's opera *Gloriana*.
1955	Premiere of Michael Tippett's opera *The Midsummer Marriage*.
1956	Sadler's Wells Ballet granted a Royal Charter and renamed The Royal Ballet.
1956	First appearance by the Bolshoi Ballet at Covent Garden.
1959	Joan Sutherland performs in the title role in *Lucia di Lamermoor*, the performance that launched her international career.

1960	Premiere of Frederick Ashton's ballet *La Fille mal gardée*.
1961	Georg Solti becomes Music Director of the Royal Opera House.
1961	First visit of the Kirov Ballet.
1962	Fonteyn and Nureyev first dance together at Covent Garden, in *Giselle*.
1963	Frederick Ashton succeeds Ninette de Valois as Director of The Royal Ballet.
1964	Maria Callas and Tito Gobbi perform in a new production by Franco Zeffirelli of *Tosca*. This classic production remained in the repertory until 2004.
1965	Premiere of Kenneth MacMillan's *Romeo and Juliet*, with Margot Fonteyn and Rudolf Nureyev in the title roles.
1965	Premiere of Peter Hall's production of Schoenberg's *Moses und Aaron*.
1968	The Covent Garden Opera Company renamed The Royal Opera.
1970	John Tooley succeeds David Webster as General Administrator.
1970	Kenneth MacMillan becomes Director of The Royal Ballet.
1971	Plácido Domingo makes his debut at Covent Garden in Franco Zeffirelli's production of *Tosca*.
1971	Colin Davis appointed Music Director.
1974	Premiere of MacMillan's *Manon*.
1984	Premiere of Peter Wright's production of *The Nutcracker* for The Royal Ballet.
1986	Anthony Dowell appointed Artistic Director of The Royal Ballet.
1987	Bernard Haitink succeeds Colin Davis as Music Director.
1991	Premiere of *Gawain*, Harrison Birtwistle's first opera for The Royal Opera.
1997	Theatre is closed for major redevelopment.
1999	The newly renovated theatre opens.
2000	Elaine Padmore appointed Director of Opera.
2001	The Vilar Young Artists Programme is launched by The Royal Opera to encourage new singers; four years later it is renamed the Jette Parker Young Artists Programme.
2001	Tony Hall appointed Chief Executive.
2002	Antonio Pappano becomes Music Director of The Royal Opera.
2002	Monica Mason appointed Director of The Royal Ballet.
2002	William Tuckett's *The Wind in the Willows* is the first of several successful family shows created for the Linbury Studio Theatre.
2004	Premiere of Thomas Adès's opera *The Tempest*, a Royal Opera commission.
2006	Premiere of *Chroma*, Wayne McGregor's first work for The Royal Ballet on the main stage; McGregor appointed Resident Choreographer of the Company.
2008	Premiere of Harrison Birtwistle's second opera for The Royal Opera, *The Minotaur*.
2011	Premiere of Mark-Anthony Turnage's first opera for The Royal Opera, *Anna Nicole*.
2011	Premiere of Christopher Wheeldon's ballet, *Alice's Adventures in Wonderland*.
2011	Kasper Holten appointed Director of Opera.
2012	Kevin O'Hare appointed Director of The Royal Ballet.

www.roh.org.uk